Xenoph
The Greeks

Alexandra Fiada

RAVETTE BOOKS

Published by Ravette Books Ltd.
Egmont House
25/31 Tavistock Place
London WC1H 9SU
(071) 344 6424

Editor – Catriona Tulloch Scott
Series Editor – Anne Tauté

Cover design – Jim Wire
Printer – Cox & Wyman Ltd.
Production – Oval Projects Ltd.

An Oval Project
Produced for Ravette Books,
an Egmont company.

To Charles Haldeman who so
loved and appreciated the Greeks.

With thanks to Manuela Berki
for her invaluable help.

Contents

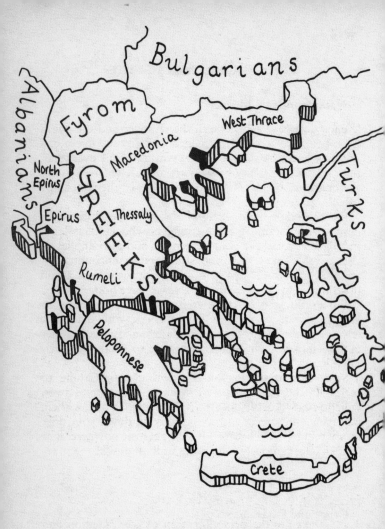

'...the Greek has the highest insecurity factor in the world.'

There are 10 million Greeks in Greece, surrounded by 59½ million Turks; 8¾ million Bulgarians; 3 million Albanians; and 800,000 Bulgarians/'Macedonians', 600,000 Albanians, 200,000 Greeks, 200,000 Serbs, 100,000 Turks and 100,000 Gypsies in Fyrom, the Former Yugoslav Republic Of Macedonia.

Nationalism and Identity

Forewarned

'Xenos' in Greek means both the stranger and the guest. Even before the time of Homer, hospitality in Greece had not only become a kind of ritual with religious overtones, but had also developed into an art form. The Greeks were the first 'xenophiles' in the world – that is, they liked any friendly stranger.

On the other hand, 'xenophobe' in Greek means the native who doesn't like the strangers who visit his land. In English though, it is more generic and also applies to the traveller who fears the strangers he encounters – which, come to think of it, is a bit odd, for if he is afraid of strangers, why on earth did he ever leave home?

But he did and he does. It is necessary, therefore, to allay the fears of xenophobe travellers, who, had they any say in the matter, would prefer to enjoy the beauties of foreign lands without also having to encounter their inhabitants.

Since this is an unavoidable evil, the first thing to realise is the importance of winning the natives over, which is fairly easy, once one knows what makes them tick. When in Greece just avoid looking down your nose at anything Greek because it will get you nowhere. The Greeks have famously long noses to look down.

How They See Themselves

The Greeks are the personification of contradiction and nowhere is this more pronounced than in the way they see themselves. A Greek, speaking to other Greeks about the Greeks, more often than not will be vehemently critical

and downright abusive about how fellow Greeks conduct themselves in any given situation. His pronouncements will be received by his cronies with much head-nodding, appropriate expletives of acquiescence and, further, with even more disparaging remarks.

However, woe betide any hapless foreigner who may suggest that the Greeks, as a race, are not the 'salt of the earth'. The same Greeks, who a minute ago were so disparaging of themselves, will turn on him – like a tigress defending her cub – and, while extolling Greek virtues, accuse him of any sins of omission or commission his country has committed against Greece since the dawn of civilization – and beyond.

It is not that the Greeks do not acknowledge their shortcomings; it is rather that they do not recognise any outsider having the right to point them out. "When we were building the Parthenon," they might well declare, "you were painting yourselves blue."

Modern Greeks pat themselves on the back because, although they have not achieved a hundredth of the achievements of their ancestors, they have managed to come through a 400-year Turkish occupation (one of the cruellest in history) with their identity, their religion, their customs and their language virtually intact.

Having missed out on the benefits of the Renaissance (for which they provided the means), having missed taking part in the Age of Exploration, the Enlightenment, the Social and Industrial Revolutions and various other epochs, they were pitched headlong into modern times some 150 years ago, and have been trying to catch up with the West ever since.

The transition was traumatic. Living in a country that has lost more than three quarters of its former territory and is perpetually on the verge of bankruptcy, they are burdened with a tremendous inferiority complex towards

6

ancient and Byzantine Greeks, because they have failed to recreate the 'Great Greece' of their forefathers.

They also bear a bizarre inferiority-cum-superiority complex towards the West. 'We gave them the light of knowledge and we have been left with the light from cheap tallow candles' is one of their favourite sayings.

On the other hand, they believe that they are the most intelligent and the most ingenious people on earth, and also the most brave.

To quote Greek writer, Nikos Demou: 'The modern Greek, when he looks in the mirror, sees himself either as Alexander the Great or as Kolocotronis [the greatest general of the Greek War of Independence] or, at least, as Onassis. Never as Karaghioz [the figure of popular shadow theatre a sort of Caliban, but minus the malice]. Yet, in reality, he is Karaghioz who dreams that he is Alexander the Great. Karaghioz of many trades, of many faces, who is perpetually hungry and who is master of only one art: play acting.'

How Others See Them

"We are all Greeks," declared Shelley. "Our laws, our literature, our religion, our arts have their roots in Greece." Yet, until recently, slang dictionaries defined a 'Greek' as 'a gambler; a card-sharp; a cheat; a highway-man' – probably because so many of the refugees who fled to the European capitals after Constantinople fell to the Turks had to live on their wits to survive.

The Greeks' dual personality has fascinated historians and travellers for centuries. Some saw them through pink glasses, some through dark, distorted lenses, others did not see them at all, but wrote as if they did. The laurel

however goes to an American, Judge N. Kelly, who managed to contain all their contradictions in a nutshell:

'In the tribunal of relentless history, the Greek has always been proven to be less than equal to circumstances, although from the point of intellect he has always had supremacy.

'The Greek is most intelligent, but also conceited; active, but also disorganised; with a sense of honour, but also full of prejudices; hot-headed, impatient, but also a fighter. [...] One moment he fights for the truth and the next he hates the man who refuses to serve a lie.

'A strange creature, untameable, inquisitive, half-good, half-bad, fickle, of uncertain mood, self-centred, foolish-wise – the Greek. Pity him, admire him, if you wish: classify him, if you can.'

Special Relationship

A Greek-American used to hand out visiting cards that stated in bold letters: "I'd rather do business with a thousand Turks than with one Greek." On the reverse was the name of his business, in handsome copperplate: *Mike's Funeral Parlor.*

The word 'Turk' alone raises the hackles of even the most cosmopolitan of Greeks, though what they really hate is Turkey as a concept and not individual Turks. Their reasons are understandable: they have had a surfeit of Turkish treatment since the mass slaughter of Greeks at the fall of Constantinople in 1453.

Throughout the resulting occupation, bands of white-kilted resistance fighters from the Greek highlands staged revolt after unsuccessful revolt.

In 1821 they were lucky: they liberated part of Greece, but at a heavy price. 'Better an hour's free life,' ran the revolutionary anthem, 'than 40 years in bondage.' Their slogan, 'Freedom or Death', still rings in the ears of the Greeks and their martial songs blare from every radio on emotionally charged anniversaries.

In a second round of warfare with the Turks the Greeks liberated Epirus, Macedonia and West Thrace, but after ten victorious years their campaign in Turkey ended in 1922 in a complete disaster – with one million dead and one and a half million refugees.

Modern Greeks not only behave as if the events of those years happened yesterday, they also blame the Turkish occupation for all the faults in their character.

Deep in their hearts they would welcome any chance to win back their 'Lost Homelands', whatever the cost. And since the Turks want to win back the Ottoman Empire, Graeco-Turkish relations can only be described as somewhat strained.

How They See Others

Apart from the Turks, the Greeks do not harbour any ill-feelings towards any other nationality.

Certainly they do not particularly like the Bulgars and the Slavs north of their borders who, not content with Greek territories already gained, have expressed the intention to extend their borders south to the Aegean.

Nor are they over-fond of the Albanians, who managed to capitalise on the Greek Civil War and drag the region of North Epirus behind the Iron Curtain with half a million Greeks in it.

When calling other nations names, the Greeks have a

collective word *coutófragi* (meaning 'stupid Franks') which encompasses the whole Western world. In all probability it is a remnant of the 13th century occupation of Greece by the Franks of the Fourth Crusade – a real clash of civilizations since the uncouth, iron-clad knights crashed into the highly sophisticated Byzantine Empire, smashing wantonly whatever they did not understand.

Of later date are various generalities: the Turks are *boudaládes* – that is, fat and stupid; or *ápisti*, meaning 'infidels'; the Slavs, the Bulgarians in particular, are *gourounomítes*, that is, 'pig-nosed', or *kommitadzídes*, after the especially murderous bandits who were roaming Macedonia at the turn of the century, trying to coerce the Greek population (then living under Turkish rule) to turn Bulgar.

The Italians are all *macaronádes* – 'spaghetti-eaters', meaning good-for-nothings (the Greeks do not forget that they soundly beat the Italian army in World War II). The French are all 'gigolos' or 'cocottes', depending on the gender, or 'cunning diplomats' (which is not meant as a compliment); Germans are workaholics; the Irish are alcoholics; the Scots are stingy; the Jews are also stingy, but fantastic bargainers too.

The Spanish are passionate lovers; the Egyptians are illiterate 'fellahs'; the Arabs are all Bedouins who would steal your fingers if you offered to shake hands. The whole of Africa is peopled by lazy *Arapádes* to frighten the children with; Americans are naïve and to be taken advantage of; Russians are *hahóli*, meaning clumsy mountains of flesh; the Chinese are as inscrutable as their language (the Greeks obviously do not say "It's all Greek to me". They say "It's all Chinese").

Last, but not least, the English are 'lords', or 'gentlemen' and the embodiments of punctuality.

The rest of the world may go hang.

Surprisingly, the Greeks do not use other nations as the butt of their jokes. They keep the sport in the family, so to speak, reviling each other from province to province, from village to village and from island to island. The Cretans revile the Peloponnesians, the Macedonians the Rumeliotes, the Epirotes the Thessalians, the islanders the mainlanders, the Athenians all the rest, and so on – until every rock and every hamlet is covered.

The international jokes which question the intelligence of one people or another are directed towards the Greeks from Pontos (the refugees from the cities on the Black Sea). For example:

Q:'Why did the prostitute from Pontos who had been in the business for twenty years commit suicide?'
A: 'Because she found out that all the other prostitutes were getting paid for it.'

Or, an announcement at the airport:

'The Pontiots are requested not to spread corn on the runway. The big bird will come down without it.'

Greek gypsies are another popular subject because of their penchant for pilfering, their peddling, their innumerable children and their unspeakable dirt.

"Wife," asks the gypsy, seeing in the rear-view mirror that one of his countless brats has fallen off the back of his Datsun pick-up truck, "shall we stop to pick him up, or shall I get you with a new one?"

Character

The character of the Greeks, even at the time of Homer, could best be described as schizophrenic.

Neither education, upbringing nor wealth maketh the Man in Greece; nor does their lack produce the Knave. From the highest to the lowest walks of life, one may encounter both Alexander the Great (noble, brave, sincere, warmhearted, intelligent, broadminded, generous) and Caliban (mean, cunning, selfish, garrulous, conceited, slothful, envious and greedy) – often in the same person.

Individualism

Individuality is the chief feature that characterises the Greeks – which precludes any attempt to box and label them as a people. They nurture an over-blown ego – which prevents any collective enterprise, unless a national disaster stares them in the face whereupon they band together in a rare display of domestic unity. They also exhibit an extreme passion for freedom of choice – which has turned law circumvention into an art and has made them incapable of comprehending words like 'discipline', 'co-ordination' or 'system'.

'I' is the favourite word of the Greeks. When a Greek poses the rhetorical question "Do you know who I am?", he clearly considers himself the centre of the world. As an old man from Delphi once explained, it is all very simple: "The Earth is the centre of the Universe; Greece is the heart of the Earth; Delphi is the centre of Greece and the Earth's navel; I am head-man of Delphi, therefore I am the centre of the Universe."

Extreme Emotion

Mercurial in the extreme, the Greeks' temperament flourishes uninhibited throughout their waking hours. This is probably why the ancient sages saw fit to carve their maxims 'Nothing in excess' and 'Know thyself' on the portals of the Delphic Oracle, in an attempt to persuade their fellow Greeks to curb their emotions.

They were not heeded then any more than they are now. From Achilles (whose wrath caused so much unnecessary slaughter under the walls of Troy) to 19th-century Admiral Miaoulis (whose temper could flare so high as to make him torch the Greek fleet, simply because he was at odds with the government), the Greeks give full vent to their emotions and damn the consequences.

Self-control – although invented by the ancient Spartans – is not only unknown but also incomprehensible to the modern Greeks. They are eager in everything: their joys, their sorrows, have no moderation. They shout, they yell, they rant and rave, for important and unimportant issues alike, in happiness and in sorrow. No emotion is considered private enough to remain unexpressed. Their excitement knows no bounds.

Their exuberance is often translated into a burning need to express themselves in some physical form. All over the world, people dance when they are happy. The Greeks are also liable to get up and dance away the deepest anguish from their heart, in a rhythm so solemn and heart-rending it makes expressionist ballet seem like a kindergarten merry-go-round.

"I have a devil inside me," explains Zorba the Greek in the homonymous novel by Kazantzakis. "Every time my heart is at the point of bursting, he tells me 'Dance!' and I dance. And my anguish goes away."

Indifference

On the other side of this red-hot coin lies the ice of their proverbial indifference towards anything that has to do with the improvement of any given aspect of public life, any worthy cause. The phrase: "Forget it, brother! I'm not going to stick my neck out in order to save the Roman* nation" is quite common and denotes the supreme unwillingness of the majority of the Greeks to show an active interest in anything that lies outside their immediate circle or will not benefit them personally.

There is a popular song to that effect, which concludes: "Yet, we sit at the coffee house – cigarette, coffee and a card-game – and never mind, never mind, brother."

Insecurity

According to an international survey, the Greek has the highest insecurity factor in the world. He is afraid to see himself as he really is, he dreads taking responsibility for his actions – and so he is unable to laugh at himself. Barricaded behind a façade of solemnity, he seeks to cover up his inadequacies, his self-doubts, his insecurity at all costs. He dreads the possibility of being considered not serious enough, and the more qualities he lacks, the more grave and pompous he appears. Two thirds of Greek society, haunted by the thought 'What will others say?', bury their spontaneity under layers of ill-fitting decorum.

*In colloquial language the Greeks still call themselves 'Romans', since the Graeco-Byzantine Eastern Roman Empire was the only descendant of the Roman one and lasted for a thousand years after its Western half had disintegrated – something the rest of Europe has difficulty believing.

Attitudes and Values

Joie de Vivre

The Greeks enjoy life to the full. They want to have a good time, to live comfortably here and now, and let the Devil take tomorrow. A Greek may squander a month's salary for a feast and then spend the rest of the month without a penny in his pocket but with a gratified smile on his face.

Greeks manage to have fun even under conditions that would plunge other people into the deepest gloom. Their unshakable optimism is well summarised in the common phrase 'God will provide', an expression which is more literally translated into 'God has', to which the obvious irreverent retort is 'He has indeed, but He doesn't give it to us.'

A popular story has it that at the time of the Turkish occupation, a Greek made a bet with a Turkish *kadi* (judge) that in a year's time he would teach his donkey to read and write. He would then win a thousand gold coins, or lose his head if the donkey remained illiterate. The Greek borrowed money on his expectations, married a lovely girl, and spent his days feasting. "Aren't you going to do anything about the donkey?" asked a friend.

"Bah," said he. "By next year , either the donkey or the kadi will die. They are old..."

If I Were a Rich Man

The modern Greek's dearest dream is to make lots of money easily (preferably without lifting a finger), but it would never occur to him to hoard his wealth. "After all,"

he says, "shrouds have no pockets."

He wants to have money in order to spend it as ostentatiously as possible – expensive cars, flashy (genuine) jewellery, designer clothes, fur coats, a house in the country, and basketfuls of flowers to throw to the performers at the nightspots he patronises. All the rest – a successful career, a good marriage, a family – come second.

An old Cretan, raising his glass to toast the company, epitomised this dream by saying: "To our future enjoyment, pals. May we be abducted by beautiful girls – rich and short-lived."

Self-Esteem

Above all others, *philótimo* is the value the Greeks hold most dear. It refers to self-esteem and love of honour, respect for one's self and for others, a sense of fair play and duty. Usually, an appeal to it can make a Greek rise above the circumstances. A slight to the philótimo, though, is akin to the oriental loss of face: a serious offence, calling for satisfaction.

Behaviour

You Never Throw Grandma From the Train

The strength of Greek family ties is such that it is not uncommon to see three generations, or even four, sharing the same flat or (more usually) living within shouting

distance of each other.

Despite the Greek 'machismo', eight times out of ten, the wife and mother (*Mamá* in Greek) is the head of the family in all but name, particularly in the cities.

Seeing picturesque photographs of Greek peasant women carrying a load of firewood and walking docilely behind their husband who is proudly riding his donkey, one would think their life is little better than that of women in the Islamic countries. Like many things in Greece, appearances can be misleading.

The well-veiled truth is that the majority of Greek men live under the cat's paw – but they would die rather than admit it. Even middle-aged bachelors, well established in their own flats, return almost daily to Mamá for a well-cooked meal and crisply-ironed shirts.

For a Greek male, mother's cooking is always the best, and this is why, in his search for a wife, he is likely to choose someone of the same ilk. After all, a Greek saying maintains that 'the wife always takes after the mother-in-law'. Greek females train all their lives to become redoubtable mothers-in-law.

There is a traditional respect for the elderly in a family and, even if they no longer rule the roost as they did in older times, they are treated with affection and their desires humoured by their children. This may not be totally unrelated to the fact that they bring with them their state or union pensions (some quite substantial), but even when this is not the case, these same children had everything handed to them on a plate until they were well into adulthood anyway, so now feel genuinely obliged to care for their parents in their old age.

Besides, what would the neighbours say if they didn't? They would be talked about as people with no 'philótimo' whatsoever.

King Herod Wouldn't Have Stood a Chance

Steer clear of Greek children. They may have angelic or cute urchin faces, but they are nearly all overfed, boisterous, demanding little menaces who are able to turn a room upside down faster than any demolition gang. Their parents may scream at them (preferably when everyone else is enjoying the sweetest of sleeps), but they spoil them rotten, giving in to even their most outrageous demands.

The result is that the majority of them develop all the worst Greek characteristics and none of the good ones. Fortunately, peer competition, higher education, the army, and the harsh facts of life once they join the workforce, usually kick them into shape and they acquire qualities one would not have thought them capable of.

Boys, being more pampered, are infinitely worse than girls. They will carry the family name – so nothing is too good for them, not to mention the old wives' tale that any refusal at a tender age will make the future man impotent. There is plenty of spanking and boxing of ears, and even empty threats ("I'll skin you alive"), but real discipline is rare.

The Greeks adore their children and will provide unstintingly for them until such time as they find a good steady job, or until they marry. Relations with parents are very rarely severed, no matter what, nor do they decline to the polite acquaintance level, so common elsewhere.

Minor Matters

The Greeks are one of the very few non-racist people in the world. They will tell you racial jokes, but only

because they cannot resist a good punchline – not because they subscribe to the sentiments behind it.

The ancient Greeks used to say that 'Whoever is not a Greek is a barbarian', but as Isocrates, orator of the 3rd century B.C., pointed out, 'Greeks we call those who share with us a common culture.'

The modern Greek still feels the same.

A great many foreigners live and work in Greece (half of them without work permits) including exchange students, political refugees and tourists who came for a fortnight and are still there ten years later.

The Greeks do not distinguish between ethnic or religious groups of any kind – rather the reverse; they will go out of their way to make those who are 'different' feel more at home. However, this does not mean to say that the bouncer doing the 'face control' at the door of a fashionable nightspot is going to let you in if he thinks you can't afford it or if you smell of trouble.

A Dog's Life

The Greeks cannot be called animal lovers, although elderly spinsters who spend their meagre income on a houseful of stray cats or dogs are not that uncommon. As a rule, pets are one of the trappings of the upper classes and of those who try to ape them.

The rest reserve their love for those animals that are useful to them, but, even when they have pets, it wouldn't occur to them to allow a cat or a dog to sleep on their bed or let it have the run of the house. In urban centres the fear of rabies (no cases of which have been reported for several decades) still moves over-protective mothers to warn their children not to go near 'the filthy dog'.

Manners

By misinterpreting the word 'freedom' the Greeks often confuse good manners with the servile behaviour they had to assume in order to survive under the Turkish yoke. Consequently, they believe that manifestations of politeness are only fit for slaves.

If you add to this their total lack of discipline (for which they are trained from a tender age), their wish to cut their betters down to size, and the general propensity to lower the standards (since it is always easier to go down than up), it is not surprising that manners are not one of the Greeks' strong points.

In Greece there is no class system with rigidly defined boundaries. The various classes, such as they are, mix casually, so bad manners can be encountered in the most unexpected places. Birth and a 'good' school are not prerogatives to any position and the concept of 'social upstart' or 'vulgar mushroom' has no equivalent.

Titles of nobility being prohibited by the Constitution, what the Greeks call the 'upper classes' are the nouveaux riches of today, coupled with the nouveaux riches of yesterday. This glittering dough is leavened with a sprinkling of intellectuals, scientists, artists, top executives and politicians.

A few representatives of real old families (those who can still afford it) grace this social cake, rather in the manner of decorative cherries. But the majority of the old families (whose lineage goes back to the Byzantine court, the Venetian *Libro d'Oro* and the powerful landowners and chieftains of the past) have sunk, financially, to the middle of the cake. They may be numerous but not so many as to make a significant impact on the mannerless multitude.

Manners in Greece, therefore, are best described as

casual. Handshakes are only for introductions; friends say 'Yia sou' (your health) and usually kiss on both cheeks – irrespective of sex or age. (Bows and hand-kissing are reserved for the priests of the Greek Orthodox Church.)

Proper queueing is almost unknown. People move (and drive) in an aggressive way and their acts are innocent of any degree of consideration towards the welfare and peace of mind of their neighbours. Don't expect too many pleases and thank yous, or anything approaching punctuality, and don't expect a Greek to keep calm in a crisis. The one who does may (if lucky) live to regret it.

At the Table

Greek eating habits leave a lot to be desired.

Elbows go everywhere, even into side dishes, or flap shoulder high during the act of food cutting; fingers are not excluded from the dishes, nor is bone gnawing prohibited – even at expensive restaurants. Communal plates of appetizers or salads are quite common and dipping bits of bread into them to sop up the sauce and eat with the fingers is an accepted practice. A lot of people manage to chew on their food while keeping their mouths wide open, and even more speak with their mouths full.

What the Greeks lack in table manners, though, they more than make up for in high spirits and conviviality. With a few Greeks around the table even the most formal dinner is bound to ring with laughter after the second course – to the benefit of all present.

Obsessions

The pursuit of easy money is one of the chief obsessions of the Greeks, as witness the half a dozen state-controlled lotteries that create a couple of millionaires every week (and also provide the Treasury with a tidy income). Most Greeks buy their lottery tickets as a matter of course every week, the way other people buy a newspaper, and then devote their day-dreaming hours to planning what they will do with the money. The day of the draw (and its consequent disappointment) over, they renew their tickets with unabated optimism.

Greece may be a poor country, but the majority of Greeks have more money than they know how to spend. Money nurtures the overblown ego of the nouvelle bourgeoisie and is manifested by their cars, furs and possessions. Their need to show off is understandable: most urban Greeks left their villages for the big cities (and for the capital in particular) only 30-40 years ago, so their urban mentality is almost nil and they need at least two more generations in order to become real middle-class.

The immense popularity of soap operas – *Dynasty*, *The Bold and the Beautiful* and their Greek imitations – is commensurate with the Greeks' insecurity. Through these they may live all the things they cannot afford or they do not dare to do in real life. Equally popular are game shows, which, by offering the participants prizes from toasters to cars, cater to their thirst for easy profit.

One would have expected the Greeks of all people to be obsessed with their classical heritage, but they are not. They are very casual about it – clearly a case of familiarity breeding contempt. They remember their illustrious ancestors only when their glory can serve some practical purpose.

What they revere most are the heroes of the War of Independence. They are also fiercely proud of the fact that they fought against the Axis powers when the rest of Europe had capitulated: "We can no longer say that the Greeks fight like heroes, we have to say that heroes fight like the Greeks," said Winston Churchill.

Greek national holidays (25th March and 28th October) commemorate these two wars with much flag waving and emotion. The Greeks may be casual about classical Greece, but should anyone impugn the least part of Greek ancestral lore, the modern Greeks rise to a man to its defence since they take any slight to their historical past as a personal affront, as a wound to their own 'philótimo'.

Leisure and Pleasure

To the Englishman his home is his castle. To the Greek it is more like a wayside inn. He uses it (with rare exceptions) for practical purposes only – to rest, to change clothes, to have an occasional meal; he doesn't really live in it. What a Greek enjoys most is to go 'out'. Anywhere is preferable to staying in and, were he able to afford it, he would spend all his free time 'out', with his family and friends.

Those who stay 'in' out of choice, and whose outings are few and well chosen, are regarded as being somewhat eccentric – not to say downright misanthropic.

The average Greek is a very sociable being: he loves crowds; he wants to see and to be seen. No other country can boast of so many and such varied coffee houses, cafés, cafeterias, tavernas, restaurants, bars, nightclubs and *bouzouki* joints – all of which are absolutely packed, seven days a week.

Eating out is a Greek's favourite entertainment, particularly if the restaurant of his choice is also providing a live show or a musical accompaniment to the clinking of cutlery and glass. Once there, he orders far more than he could possibly consume, as if trying to make up for years of starvation. (Many remember the last famine, during the German occupation in World War II, which had, in the Athens area alone, some 350,000 casualties.)

A Greek's idea of how best to spend his evening is to be with a *paréa*, that is, two or three couples from his vast collection of friends (their offspring included if no member of their families can be bullied into babysitting), merrily established at a taverna table (set in the open air from late spring to late autumn). There he proceeds to eat (excessively), to drink (in moderation) and to talk inanities (volubly) until late into the night, while his children maul the ever-present stray cats or fall asleep on their chairs.

This way of living is not peculiar to metropolitan life. There is no village in Greece, however humble, that does not boast the inevitable coffee houses and a couple of nightspots. There is no square throughout the country that on sunny days is not filled with tables and chairs on which most of the population of the area lounges as if there's no tomorrow.

A Greek needs at least four straight-legged chairs in order to lounge properly: sitting on one, he places each foot on the rungs of two more, directly in front of him; then, tilting back the chair he is sitting upon, he supports himself by draping one arm across the back of another chair, strategically placed at his side. He may even need a fifth chair, on which to park his coat. (Modern cafés, by using untiltable chairs, have rather spoiled this ancient sport.)

Observing this, one might wonder who works and when. Rumour has it that only some 5% of the Greeks really work. The other 95% avoid it if they can.

Time Out

For the average Greek, work is something he does (cursing his luck) between holidays. There are some twelve official holidays in Greece, plus 22 working days of paid summer leave. These combined with the weekends, sick leaves and various strikes, enable an enterprising Greek to spend approximately one half of the year doing what he enjoys most: nothing. The result is that during the fortnight around the Christmas and Easter holidays and the two hottest summer months (July and August) the country almost comes to a standstill.

For short holidays – weekends and such – the Greek packs his wife, kids and mother-in-law in his car and heads for the countryside with the determination of a migrating lemming. Once there, he turns the kids loose and then he sits once more at a taverna table. On Sunday night about one third of the Greek population pours back (with many road accidents) into the hapless capital, through just three bottlenecks that pass for highways.

For longer holidays and for vacations, the obvious choice for those who live in the cities is to touch base, so to speak – that is, to return to their village of origin.

Middle-class Greeks also holiday abroad a good deal, mostly in organised groups. Shopping at department stores (upon which they descend like a swarm of voracious locusts) is their first priority – sightseeing comes a definite second. Anything bought abroad is thought of as being of better quality, particularly if it is a bargain, and London sales are a great favourite. In fact, the slang word 'megla' is a corruption of the phrase 'Made in England' and is used to denote elegance and supreme quality. By contrast, the word 'jampa', derived from 'Made in Japan', means very cheap.

Sex

According to a recent survey among well-travelled naughty girls ('good girls go to heaven – bad girls go everywhere'), the laurels of the 'Latin lover' grace the curly heads of the Greeks – to the great frustration of the Italians who come a (panting) second.

It is a well-known fact that female tourists from colder European regions flock every summer to the Greek islands with only one thing in mind: sex. There they meet with like-minded young men – the notorious *kamákia* (loosely translated as 'harpoons', because they 'hook' the girls) – who the rest of the year are ordinary, usefully employed, working men or students, but who, come summer, go on a sexual binge. They regard their amorous efforts as a service to humanity – giving the inhibited, pale northern damsels a heady taste of sun-drenched virility and of tangy, velvet nights by the sea.

The Greeks are a very sensual people. Although there appears to be a middle-class restraint towards sex in general, nothing could be more misleading, because in fact their conservatism is only skin deep. Small wonder, when they are raised on the most adulterous mythology ever compiled, instead of innocuous nursery rhymes.

Were you to eavesdrop on a 'warm' conversation among a group of friends (whether the group is all male, all female, or mixed), you would scarcely believe your ears. The descriptions of what they did, how they did it, how many times and with whom (most Greek men and women are of the type who 'kiss and tell' – in the strictest confidence, of course) are so blatant and explicit and embellished with such graphic details that they would make the unexpurgated version of Aristophanes' plays seem puritanical by comparison.

Most men, whether happily married or not, consider

themselves honour bound to cast out lures to any presentable female. The ensuing affair – as casual as it may be brief – rarely has repercussions on the marital status of either partner. The Greek male has affairs in order to nurture his ego and to add spice to his life and, no matter what he may say to the contrary, very seldom can he be coerced into divorcing his wife to marry his mistress. His wife – secure on her throne as queen bee of the family hive – will just shrug off the affair (if she hears about it), saying: "Poor darling, he can't say 'no' even to a female cat. He's a man; how can he go against nature?"

The wife is not averse to paying him back with the same coin. Yet usually, the more unfaithful the wife is, the more her husband believes in her. "Cuckold your husband and don't resort to spells and philtres!" advises the old adage for achieving marital bliss.

The Greeks, despite their sensuality, or perhaps because of it, seem to have no need of the sexual aids so much in demand elsewhere. There are few sex shops in Greece and porno movies are watched more for the fun of it than as an inducement to a sexual act.

On the other hand, the Greeks have great faith in the aphrodisiac qualities of oysters and of olive oil, while they believe that fizzy drinks and soda water are quite detrimental to their virility.

For the Greeks, sex is God's gift to humanity and they enjoy it for its own sake. (So much so that Greece has one of the highest abortion rates in Europe.) If one tries to explain to a Greek the precept of the western churches that making love for other than procreation purposes is a sin, he will laugh and say that, if God had such an intention, He would have made man and woman come on heat once a year, like the animals.

The fact is that 'scratch a Greek and you will find a pagan'. The concept of 'sin' has very superficial roots in

everyday Greek life. So, at least in the cities, there is no such thing as 'living in sin' with someone and, since by law women do not take the husband's name anymore (children can take the name of either parent), there is no way of knowing whether a couple is married or not. The words 'husband' and 'wife' are used casually, regardless of actual marital status.

Eating and Drinking

This is the land where ambrosia and nectar were invented, but so, of course, was hemlock. In true Greek style, there are many subtle and exquisite dishes, but there is also some commercial fare which will not kill you, but tastes as if it might.

The ordinary Greek national dish is *phassoláda*, a thick bean-tomato-and-carrot soup (a meal in itself, particularly when supplemented by a smoked herring), while on Sundays and festive occasions roast baby lamb or kid, with potatoes baked in its gravy, is a decided first.

Though each region has its own specialities (succulent dishes with meat cooked with various nuts and dried fruit, pies with original fillings among layers of wafer-thin homemade pastry, colourful stuffed vegetables of any description, etc.), the general tendency for an everyday meal is to make casseroles or stews.

Most food is cooked with translucent, pale gold-green olive oil or oil-derived margarine, which with the addition of ripe tomatoes, makes it swim in a bright scarlet sauce, ready to be eagerly scooped up with pieces of bread. 'White' dishes are flavoured with the tang of fresh lemons or finished with a creamy egg-and-lemon sauce.

Freshly-slaughtered very young animals – veal, baby lamb, kid, suckling pig, spring chicken – are the Greeks' choice of 'good' meat. The silver and gold of Mediterranean fish – sea bream, dentex, gilt-head bream, sea bass, red mullet, sardine, whitebait and many others – form the basis of many delicately flavoured dishes, quite different from their Atlantic cold water cousins, smaller and more tasty. Crustaceans, cephalopods and shellfish – fried, grilled or raw – make mouth-watering appetizers or even main dishes.

Vegetables – all kinds of fresh beans, aubergines, okra, courgettes, artichokes, potatoes, peppers, beetroot, broccoli, etc. – are cooked as main dishes (whether as part of a meat casserole or by themselves) and rarely eaten as garnishes.

The Greeks have a sweet tooth, so the variety of sweets and pastries they produce is endless. They make sweet preserves and jams from all fruits (including rose petals, orange blossoms, water-melon rinds and baby aubergines); they bake hundreds of traditional Greek breads, cakes and biscuits, and they copy all the Western confections and all the sinful, syrupy Middle-Eastern concoctions of crisp filo pastry, chopped nuts and spices.

Greek mealtimes are as erratic as the Greeks themselves: lunch between 1.30 and 5.30 p.m. (depending on the individual's working hours) and dinner after 10 p.m. Afternoon tea is non-existent, although a cup of coffee after the siesta hours is most welcome.

Despite the fact that most Greeks say scornfully, 'I never eat breakfast' (as if breakfast was a degenerate, almost depraved, habit), they usually have a cup of coffee, taken black or white, with a couple of rusks or biscuits, around 7.30 in the morning, before setting out. At 11 a.m., being in urgent need of further sustenance they have a *tyrópitta* (a filo pastry oozing hot *féta* cheese)

or any of the 1,001 tempting confections bakeries and snack shops provide.

Around noon, those who can afford the time meet friends for an aperitif (*ouzo* or beer) and a *poikilía* (a hot or cold appetizer) which can be a full meal in itself.

In recent years whisky has almost become the national drink. Even in the smallest villages, far from the metropolis, the fiery local spirits *rakí* or *tsikoudiá* have now been relegated to second place. The Greeks drink 45 million bottles of whisky per year – the world's greatest per capita consumption.

Meeting with friends, by chance or by design, usually calls for a drink (or several) at any time of the day or the night (there are no licensing hours in Greece), but it is very rare for a Greek to drink alone. Consequently there are few Greeks with drinking problems.

Everyday lunch or dinner is a simple affair: one dish – say, aubergines with minced veal and tomatoes, or pork with celery or chicken with okra – plus a tomato or lettuce salad.

Cheese, especially crumbly white féta made of goat's or sheep's milk, is eaten during the meal and not at the end of it, and forkfuls of food alternate with pieces of bread dipped in the meat juices or in the salad dressing.

Delicious, sun-ripened fruits, so abundant in Greece, are the usual dessert and Greek coffee always rounds off a hearty meal. This is served black, in tiny cups, in one of numerous variations concerning the proportion of coffee and sugar to water. The Greeks would not think it a proper cup of coffee unless it has a creamy brown foam on top and a quarter of an inch of muddy residue at the bottom. Aficionados drink it scalding hot, in small sips – the first followed by a profound sigh of satisfaction.

Culture

Compared to the classical one, modern Greek culture is but a short, pathetic footnote in a volume of monumental proportions. Yet, judged independently, without the burden of its classical heritage, it is far from contemptible.

Its writers and poets (two Nobel prize winners among them) have produced, and continue to produce, works that could have made quite an impact in global literary terms had they been written in a more widely spoken language. Its composers, painters and artists often gain international acclaim for their work. In fact, more often they first become famous abroad and then receive the applause of their fellow countrymen.

All this, however, is beyond the average Greek. There are households where the only books (apart from schoolbooks) ever to cross the threshold are a couple of garishly gilded encyclopaedia sets entirely for decorative purposes. There are mothers who say to their child: "I bought you a book last year, what do you need another for?"

Most Greeks read nothing heavier than newspapers and popular magazines, the more sensational, the better. The books that are most enjoyed are best-sellers or trashy paperbacks – novels, crime stories, romances, either in translation or by Greek authors. Serious work rarely sells more than a couple of thousand copies since only one Greek in four reads one book a year. The same applies to music, theatre and the fine arts: when something really good is produced, it is appreciated and enjoyed only by an elite. Classical music is only played on the radio when someone famous dies.

All in all, in modern Greece, culture and the average Greek are like two trains running on parallel lines: they seem destined never to meet.

Meaningful Music

On the other hand, when the verses of important Greek poets, like Gatsos, Ritsos or Nobel prize winners Sepheris and Elytis, were put to popular music by composers of the calibre of Theodorakis or Hadzidakis, they were sung all over Greece. Their beautiful, elliptical verses sing of love and betrayal, joy and death, past glories and lost causes.

There is only one swallow and the sea is dear,
To make the sun turn about, it takes a lot of work.
It needs thousands of dead to push at the wheels,
It needs the living, too, to keep offering their blood.

On the blond sand of the beach
We wrote her name.
Nicely the breeze blew,
And the writing was erased.

Don't cry for the Roman nation.
At the point of knuckling under,
When the knife has reached the bone
and the yoke is at its neck,
It jumps up anew, and takes courage and grows bold,
And pierces the dragon with the sun's spear.

Spiritual sun of Justice, and you glorifying myrtle,
Do not, please, do not, do not forget my country.

Their heroic, poignant, often melodramatic words have found instant appeal with the Greeks – of whom Edith Hamilton once said, "They are never sad. They just become elegiac."

It is natural for the extrovert Greek to express his soul through the emotional language of music – and given the right circumstances, sometimes he succeeds. The title tune

of *Never on Sunday* typifies the popular form of genuine *rembética* (songs that originated in the sub-culture of the demi-monde). This music and folk music, along with modern works inspired by them, express the essence of what it is to be Greek.

There is an underlying sadness and sense of loss in most of the old rembética that is reminiscent of certain Irish ballads. They are sung to the tingling sound of the mandolin-like bouzouki, and their cadences (four or five themes with endless variations) are thousands of years old – echoes of many bygone civilizations.

The Greeks constantly quote the lyrics of songs in everyday speech. Since most songs tell a story, relate a theory or make a statement, there are few situations where the words of one song or another do not apply. For example:

> You came home again at three o'clock in the morning!
> Crazy-girl, why are you behaving like this?
> Take care that you shape up, and collect yourself,
> Otherwise you'll die destitute on a straw mat.

> Back to back in the same bed,
> With our ego as a top sheet.

> During one's lifetime a lot of roads are opened up,
> And whichever you like you take to where it may lead.
> But there is also a small wicked path,
> That goes straight to the great downhill plunge.

> Life has but two doors. I opened the one and entered.
> I leisurely walked about during the morning hours,
> And by the time dusk came, I exited through the other.

All this sounds wonderful but there is an inevitable catch. Most Greeks believe that the louder the music the better, so the majority of live music bouzouki joints

employ loudspeakers suitable for an Olympic stadium.

However the cognoscenti congregate in tavernas where the singers use the minimum of electronic aids or none at all, and the air is thick with cigarette smoke and sentiment. Here one can also see, beautifully executed, the expressive dances of old – whether solemn or joyful, or full of oriental sensuality. One such dance is described by painter and humorist Bost:

'The man – coat unbuttoned, a cigarette hanging from his lips, bitter expression and downcast eyes – stood motionless in the middle of the floor. As if to balance himself, he opened his arms wide like wings, like a great wounded bird, and started. He was a good dancer. He belonged to another world – he didn't care about us, we didn't exist for him – he was dancing for himself only. A solemn, proud and brave man, who was at odds with God and who was challenging Death. Death was trying to grab him, the man was taking a few hesitant side-steps to avoid him. In the end the man would escape – being more cunning and daring than Death. He was positioning himself to the right, to the left, with deliberate ritualistic movements. Each step was weighted and studied as if he were avoiding land mines.'

The Greeks being the veritable nightbirds they are, all such entertainment starts about midnight and the star singers only come on stage after 1 a.m. (Police raids to enforce spasmodic Government attempts to get Greeks to bed earlier are merely regarded as a nuisance.)

No-one is bothered by the fact that the morrow is probably a working day. Happy after a night of unbridled musical passion, they will straggle tipsily to bed, sleep it off for a few hours, and then go to the office looking like a bleary-eyed raccoon.

Language

The Greek language has changed less from the time of Plato (four centuries B.C.) to today than English from the time of Chaucer (14th century A.D.) to the present.

Greek was for many centuries the common language throughout the ancient and medieval world. No educated Roman was without it and even Queen Elizabeth I spoke and wrote Greek beautifully. Thus thousands of words were incorporated into the Latin vocabulary and thence passed to the European languages of today.

In English alone, about a third of the words are either transliterated Greek or of Greek origin. Apart from most medical, scientific and literary terms, as well as hundreds of names for plants, animals and elements, Greek-derived words in everyday use range from 'alms' to 'zoo', with thousands of surprising entries in between.

Had it not been for the Greeks who first called *Yeshua* **Jesus**, surnaming Him **Christ** (the Anointed One), where would **Christianity** and **Christmas** be? The **Church** would have no **Bible**, **prophets**, **angels** in **Paradise**, **apostles**, **martyrs**, **bishops**, **hymns**, **carols**, **choirs**, **cloisters**, **crypts**, **monasteries**, **rosaries**, **chalices**, **parishes**, **cemeteries**, **tombs**, **idols**, **coffins**, **litanies**, **exorcists**, **heretics**, **atheists**, **blasphemers**, **satanists**, **demons**, **devils** or **dogmas** – and no-one would say **amen**.

Nothing and no-one could be **European**, **mysterious**, **brilliant**, **ethereal**, **patriotic**, **phlegmatic**, **animated**, **tragic**, **diplomatic**, **automatic**, **democratic**, **nostalgic**, **magnetic**, **domineering**, **hilarious**, **glamorous**, **tropical**, **aromatic**, **hysterical**, **ironic**, **famous**, **ingenious**, **nervous**, **gorgeous** or even **anonymous**.

There would be no **strategy**, **tactics**, **politicians**, **ethics**, **aristocrats**, **butlers**, **dandies**, **nymphomaniacs**, **anarchists**, **Bolsheviks**, **technocrats**, **schizophrenics**, **heroes**, **history**,

schools, arguments, organizations, symbols, diamonds, pirates, treasure, climates, lions, tigers, roses, paper, ink, letters, boxes, thermos, cups, cans, cherries, diets or pizza with peppers on plastic plates.

The arts would have to do without ballerinas, poets, dramatists, scenes, theatres, comedy, cinema, circuses, stars, acrobats, melodies, guitars, chords, symphonies, orchestras, television, programmes, critics, photographs and scandal.

And technology would lack ideas, architects, metal, discs, hydraulics, engines, electrics, cameras, lamps, polyurethane, varnish, chimneys, disasters, and the atom bomb.

Modern Greek is (grammatically and syntactically) a simplified descendant of the Greek spoken by Plato and his friends, but it has retained unchanged more than 80% of its original vocabulary. The rest is made up of transliterated foreign words (French, English, Italian, Turkish and others), witnesses of the many cultural influences. For example, a Greek says party, pub, manicure, casserole, trolley, drive-in, crayon, rouge, goal, parking, toast, *adio* and everything is O.K.

A 'War of the Languages' has been raging for ages between the Left-wing and the Right-wing literati. The latter want the Greeks to speak 'pure' Greek (the language in which the Gospels were written, or almost), and the former want an oversimplified, colloquial form of 'demotic' Greek (that which is spoken in the street), because doing away with the past and its aristocratic language would be really 'progressive'. It is as if the British suddenly decided to drop the King's English and start teaching Cockney at their schools.

There is a middle way but it is ignored by politicians so, depending on the party in power, the Greek language goes back and forth – with the school pupils caught in the middle like the children of divorced parents.

Sense of Humour

Although many Greeks are equipped with a tremendous sense of humour and razor-sharp wit, what *hoi polloi* enjoy (and understand) most is coarse farce, couched in vulgar sexual terms. The new bourgeoisie behave as if they have just discovered the existence of their genitals and talk (or rather, giggle) about little else.

Every season there are at least half a dozen revues playing to packed houses in which political satire (the staple of any Greek show) is interwoven with blatant sexual innuendo – often in verse, to the tune of some popular song. For example, an important politician can be described as having balls so large they plough the ground when he walks; another may be deemed so weak that he cannot get it up; an unpopular one is denounced as fucking the people with his decrees; and all economic measures (regardless of who is in power) are described as a cucumber up the arse of the workers.

Since post-war Greek society is going through a phase of protracted adolescence, such a phenomenon was to be expected. Happily, true wit has survived the onslaught of vulgarity and, happier still, it is not the exclusive privilege of the educated. If anything, one appreciates its spontaneity and originality more when one least expects to encounter it.

An almost illiterate Cretan peasant who had the job of caretaker at the German War Cemetery in Maleme (site of the Battle of Crete) was reprimanded – through an interpreter – by a visiting German general. He wanted to know why an employee of the German government was not able to converse in the language of Goethe.

With Aristophanean aplomb, the Cretan offered the reason: "My friend, tell the good general that my Germans do not talk."

Word-play and puns are so much part of everyday speech and take such unexpected twists and turns (since the Greeks will appropriate any foreign word and decline it according to Greek grammar), that colloquial language is indeed 'Greek' to anyone not bred to it.

The Greeks are very fond of jokes and always find the time to tell their friends the latest they've heard of the particular batch currently in fashion. 'Bobos', a foul-mouthed, over-sexed brat, is an all-time favourite:

The teacher is explaining to a class the facts of life, concluding that after puberty little girls can have babies, if they are not careful. "Then I could have a baby, Ma'am?" asks nine-year-old Maria. "It would be difficult, but, yes, there have been cases –" answers the teacher. "And I?" pipes up five-year-old Helen. "You? Certainly not!" From the back of the class, Bobos' voice is heard full of confidence: "I told you, Helen, that you needn't have worried."

Conversation and Gestures

A Greek cannot talk unless he has his hands free, and a soft-spoken Greek is one who can be heard only as far as across the street. Two Greeks having an amiable conversation sound as if they are ready to murder each other, and a party of exuberant Greeks having a good time could be described as a pack of hounds that has just sighted the fox.

Because they are so extrovert in character, heated discussions on any current subject – politics in the lead – flare up among complete strangers in the most unlikely

places. The Greeks air their views not only in the innumerable coffee houses, but in the street, in buses or in shared taxis. Such debates may last any length of time and the interlocutors may illustrate their arguments with examples drawn from their private lives (things an Englishman would not dream of disclosing even to his dearest friends), without deeming it necessary to introduce themselves. The debate over, they part as complete strangers as before.

The average Greek has definite views on everything – from space travel to the price of tomatoes. He is also fond of philosophising on life and on the nature of things, using trite aphorisms – a pastime that has won the name 'vine-philosophy', since it resembles the prattle of wine-fuddled idlers.

The Greek loves to hear himself speak, and when transported by his own rhetoric his wild exaggerations and sweeping generalisations can easily mislead the unsuspecting: there are visitors who leave Greece firmly believing that the Greeks still worship the twelve Olympian gods.

Insultingly Yours

Greeting someone from afar, either arriving or departing, one may shout 'Yia sou' and wave, but must take care never to wave with the fingers splayed out and the palm towards the person. This is a serious insult (equivalent to 'Damn your eyes'), usually reserved for fellow drivers on the road whose ability at the wheel does not meet with your approval.

When in anger among strangers, the Greeks are careful not to appear vulgar by using words and gestures not

befitting their station in life. But, among friends, insulting gestures are quite common and are even used jokingly.

One such gesture, meaning that one couldn't care less about another person's opinion, demand or even threat, is to make a forceful downward and inward movement, towards one's genitals. This is usually accompanied by the phrase 'at my balls', 'at my prick' or 'at my cunt'. This means: "What you're saying is of so little interest to me that, were I to write it down, I'd use a surface impossible to write on."

A less common but more insulting gesture is similar to a middle finger signifying 'up yours', but the hand is turned sideways and, with a rhythmic back and forth movement, the finger pumps horizontally. The obvious meaning is 'fuck you'.

When illustrating that someone is bad or impossible to deal with, one says *léra* (dirt) or 'May God guard you' and, taking the edge of your own lapel with two fingers, shake it as if to free it of dust.

The equivalent to the expression 'You're fibbing!' is an action which caresses the right cheek downwardly, with the back of the fingers of the right hand as if checking whether one needs a shave, accompanied by the slang word '*ksùres!*'.

The Greeks, male and female, at all levels of society, sprinkle their speech with swear words as a matter of course – not only in anger or frustration, but also as a joke, or as a form of endearment. The originality and colourful imagery of Greek expletives vary from the common swear words to sexual images that would baffle a sailor.

The most popular of all is *malákas* (masturbator) in all its derivatives, ranging from 'stupid' to 'good, honest fellow' or 'my dear friend'. The noun, *malakía* has generally the meaning of 'nonsense', but it is also used to describe errors committed or things one disapproves of.

Gamó to (fuck), like its derivatives, is used more or less like 'damn!' and, unless spoken in anger, has become more a figure of speech.

When swearing in earnest though, 'fuck' is used with family or religious terms, like 'fuck your mother/father/ entire clan/God/Christ/Holy Cross/*Panaghia* (Virgin Mary)/ Holy oil lamp' and many others, depending on the imagination of the speaker. (The prize should go to the old sailor who used to say "Fuck a barrel of Saints with Christ as a lid!")

Such insults being very serious indeed, if one does not want to face their full implications but simply to swear in order to let off steam, one simply changes the 'you' to 'my' (i.e. 'fuck my mother', etc.). This deprives the other person of the legitimate opportunity to return the compliment. All the above can also be used without the prefix 'fuck', by saying only 'my/your Christ' etc. – the meaning is the same, but it doesn't sound as bad.

There are many other interesting flowers in the garden of Greek abusive language, e.g: 'I have a cucumber up my arse' (the work I'm doing is very difficult); 'He/she has a wide arsehole' (he/she is inordinately lucky); 'Go to the Devil', 'Go get fucked', or even 'Shit on me' (I disagree with you/Leave me alone); 'God gave him a foreskin and he's opened a tannery' (he masturbates all the time/he's a good-for-nothing); 'Take care, for I'm going to throw you into the pit with the up-yours fingers' (self-explanatory); 'He made my balls go dizzy'/'He made my balls swell up', (he's a very annoying person); 'Take your finger out of your arse' (get to work); 'He needs an up-yours finger' (he needs some pressure or some incentive in order to work); 'You've done it arse-like/cunt-like' (you've made an awful faux pas, you did a job very badly); 'Cunt in copperplate' (ditto); 'Your mother's arse'/'Your aunt's arse' (you couldn't be more wrong); 'I'll make him fart wool'

(I'll make him tremble with fear).

'Get back in place, cunt of mine, and stop prick-sailing' denotes extreme surprise; 'Come and pull at my nipples to build up your muscles' means you're talking nonsense; 'Blue pricks' (ditto); and 'Roll it up and stick it up your arse' answers the query 'What shall I do with it?', even if the object in question is a cupboard.

When calling someone names, *putána* (whore) and *pústis* (passive homosexual) are the most insulting and they are all used in combination with the above. The act – *putaniá, pustiá* – means doing someone an ill-turn or something reprehensible behind his back. *Keratás* (horn-bearing man) literally means a cuckold, but it is used regardless of its actual meaning as a milder invective.

Then there is 'donkey' or 'mule' (a boorish person); 'arse-boy' (ill-mannered, irresponsible and impudent); 'dirty dishcloth' (a worthless woman). This, being but a small bouquet of Greek linguistic 'flowers', should be tied up with the appropriate expletive: *Skásse* (burst) meaning 'shut up!'

Custom and Tradition

In Greece everyone believes in the power of the evil eye, regardless of what he may claim to the contrary. There is not a child who does not wear a turquoise-coloured bead (sometimes with an eye painted on it), as an amulet against it – and for the same reason strings of such beads adorn the necks of horses and donkeys in the country, or rear-view mirrors in the city.

A mixture of tradition and superstition still permeates several aspects of Greek life. For example, a Greek never

dares say how pretty, handsome or elegant a person looks (especially a child) without accompanying his comment with a *ptt-ptt* sound – as if politely spitting out a fragment of tobacco that has stuck to his lips. He also 'touches wood' to avert the envy of the gods whenever he is boasting of something.

It is bad luck (not to mention bad manners) for the Greeks not to offer some kind of refreshment to anyone visiting their home, regardless of the hour of the day or the brevity of the visit. Traditionally it is a spoonful of sweet preserve on a tiny plate, accompanied by a glass of fresh water, but nowadays it can be anything: coffee, pastry, chocolates, ice cream or alcohol.

Visitors play an important role in the continuing prosperity of a home (i.e. someone who is not going to spend the night in the house is not supposed to comb his hair or cut his nails on the premises) and none more so than the person who first sets foot in a house on January 1st. Well-meaning people are therefore much sought after as early-morning visitors. They must put their right foot forward entering the house, simultaneously wishing the household 'Happy New Year'. In older times they would bring a pomegranate, which they would hurl on the floor upon entering, the spilling of its many seeds supposedly bringing prosperity for the rest of the year.

Most customs are related to religious rituals or particular feast days, although many of them are of pagan origin and have been whitewashed with a dose of Christianity. As a rule the Greeks are not terribly religious, at least not in a bigoted, self-righteous way, because the Greek Orthodox Church does not chase after them with threats of fire and brimstone if they don't show up at Mass, nor does it poke its nose into their private lives.

A religious custom that dates from pre-Christian times is that of the votive 'offerings': people who are sick or in

danger of their life vow to bring to the Saint of their choice a token of their gratitude, a sort of bribe for interceding on their behalf. It can be anything – from building a chapel to offering a candle.

The Greeks also offer a *táma*, a thin silver plaque embossed with a scaled-down model of whatever is being asked to be made healthy or saved from peril (hearts, eyes, feet, hands, children, even houses, boats and cars). These offerings festoon the frames of venerable icons, icons which are not regarded as mere paintings but as holy in themselves. A few are even purported to work miracles, and the one of the Virgin Mary in the island of Tinos draws more pilgrims than Lourdes.

A charming tradition related to christening a child is that the godparent has to provide it with a golden cross on a chain, plus a complete outfit of Sunday clothes, including shoes, otherwise the child will 'stumble' throughout its life and will never have enough clothes on its back.

Life After Death

The Greeks' unflagging optimism is nowhere more apparent than in their funeral customs. Since no-one considers himself a sinner, they are convinced that when they die they will go to specially reserved clouds in Heaven. Thus death does not hold much terror for them.

Funerals are very elaborate affairs, followed invariably by coffee and brandy for all who attended and by a wake (with a fish supper) for close relatives and friends. A memorial service is held on the 40th day after death, when spoonfuls of a delicious concoction of boiled wheat, various nuts, seeds, raisins and sugar are eaten in

memoriam.

Since cremation is against the tenets of the Orthodox Church, the Greeks rest in graves constructed of marble and surmounted by a large white marble cross. (Three years after burial the bones are dug up and placed in private cenotaphs, thus solving the problem of over-crowding.) Flowers, either fresh or made of plastic, and a constantly burning oil lamp in an elaborate glass case are the standard decorations. Brightly coloured plastic buckets hang incongruously behind the graves bearing witness to the regular washing of the marble slabs by devoted relatives.

Cemeteries are full of people all day and every day, and priests in vestments perambulate the avenues ready to answer the call of anyone who wishes a ten-minute memorial service sung over the grave of a relative or friend. At night, the glowing oil lamps under the tall cypresses give Greek cemeteries a serene rather than haunted atmosphere.

The belief of the Greeks in afterlife (and a good one at that), means that Easter is their greatest religious event. It starts with Holy Week, during which nearly everybody fasts and drops into church, if only once, and for a few minutes, to hear the special Masses. This is followed by the Holy Friday procession of the flower-bedecked bier of Christ; and culminates in the Holy Saturday open air midnight Mass. Finally, fire-crackers and fireworks light the night sky to show that 'Christ is risen' and the streets fill with people bearing home their lighted candles.

Easter Day is inconceivable without lamb roasted on a spit and without cracking the shells of red-dyed hard-boiled eggs with all present at the feast. (One person holds his egg in his fist, point up, and the other hits it with the point of his egg. The latter says "Christ is

45

risen!", the former replies "He is, truly!". Then the eggs are turned bottom up and the roles reversed.) In the end the family has a pile of cracked eggs to peel and slice up for an excellent egg salad the next day.

What Is Sold Where

Greek shops have peculiar hours which vary from day to day, from summer to winter, or even depending upon what they sell.

The shop that is open at all hours is the kiosk: a tiny cabin, usually perched precariously at the edge of the pavement and festooned with newspapers and magazines. The vendor inside it sells cigarettes, chocolates, postage stamps, bus tickets and a million and one other things (from ice cream and soft drinks to playing cards, aspirins and condoms) depending on how enterprising the owner is. If the kiosk is more up-market, i.e. if it operates from a hole in the wall, there is no end to what it may be selling.

A number of interesting combinations are offered in particular shops. For example, chemists· (*farmakéon*) sell drugs, some cosmetics and orthopaedic sandals, and bakers may sell milk, yogurt and soft drinks. Bakeries will also undertake to roast on your behalf (for a fee) any dish you have ready for the oven, or to bake bread or biscuits you have prepared. They may even lend you their own huge, black baking trays for the purpose.

Wines and spirits may be sold from any shop connected with foodstuffs since a licence is not required, and at all hours, the only exception being election day when you can buy a bottle to drink at home but you cannot have a drink at any public place unless, of course, you can persuade your waiter to put your whisky in a coffee cup.

46

Health and Hygiene

The Greeks behave like ostriches about their health; if they don't talk about their symptoms to a doctor, the ailment will go away. Nevertheless, a full description of their sufferings (down to the last gory detail) is relayed to anyone prepared to listen and, since every other Greek is a self-appointed Hippocrates, they get a multitude of diagnoses and proposed cures. In general they look at illness or health as pre-ordained, saying: 'When your oil lamp has run out of oil, neither Saints nor doctors can be of any help.'

The Greeks may not like going to a doctor, but they will take medicine at the drop of a hat, and this is why there are so many chemists in Greece – business is always booming. The majority of drugs (except for the addictive ones) are sold over the counter – and so are contraceptive pills. Thus antibiotics and other medicaments are swallowed as if they are jelly beans. The Greeks never think of consulting a doctor about whether the drug that cured similar symptoms in their neighbour's third cousin will have the same beneficial effect in their case. They just take it and damn the consequences.

However, when a doctor prescribes a treatment, the Greeks seldom follow it to its conclusion. A G.P. reports that only 50% of those in need of medical attention go to a doctor before their condition has considerably deteriorated. Of the ones who do, only half get their prescriptions filled, and a half of those actually take the medicine. Less than half of the last group finishes the course and goes back to the doctor for a final check-up. (Don't bother to count: it comes to about 5% of the original number.)

Hypochondriacs are rare and the only microbes the average urban Greek dreads are those that stray cats and dogs (or possibly his neighbour's pets) may be carrying.

So, since the Greeks play it tough, very few believe in preventive medicine, regarding doctors as a necessary evil, i.e. they only go to them when everything else has failed.

Despite the fact that eight out of ten Greeks enjoy free medical care and they contribute only a percentage of their pay towards hospital costs or the purchase of medicines, the national health system (and the more upgraded medical aid provided by various unions to their members) does not cater for their requirements. The corruption inherent in the Greek public sector is nowhere more apparent than in the majority of state-operated hospitals and in the quality of the services they provide.

Rumour has it that by slipping an envelope with a substantial amount of money to the surgeon who is going to do the operation, one will ensure better-than-average treatment. Bed and ward allotment are also often subject to bribes and although nurses are real 'angels of mercy', a large number of orderlies and attendants function rather like hotel personnel – the larger the tip (given in advance), the better the service.

State-operated hospitals might look as if they belong to a Third World country, but behind the façade of ill-kept buildings and of not so spick-and-span wards, they boast some of the best doctors and nurses in the world. Order and cleanliness, or their lack, are the result of management, which has nothing to do with the medical personnel.

Another factor which gives Greek hospitals their Third World look is that the relatives of the patients come and go as they please, at all hours (even spending the night in the wards), not so much as visitors but as a kind of private nurse, actively ensuring the well-being of their loved ones. At least four such 'visitors' per patient, per day, is the average.

It is not surprising that those Greeks who can afford it,

or whose insurance or social security covers the cost, prefer the luxury of private clinics. The catch here is that their five-star accommodation and service are not always backed up by five-star doctors.

Cleanliness

The Greeks come second only to the Japanese as far as their own cleanliness is concerned. Home scrubbing is a point of honour and a favourite pastime of at least 90% of Greek housewives – hence the popular saying: 'Cleanliness constitutes one half of nobility'. Since the Greeks have little sense of privacy, all doors to all the rooms (bathroom excluded) are always left wide open, showing that the mistress of the house is not trying to conceal any untidiness.

Greek women are inordinately houseproud. Even when they have a job, they slave away the remaining hours to keep their home clean and tidy and to cater to the needs of their families. They may have all the modern appliances, but elbow grease is what keeps the home machine running – particularly since the majority of their men, like regular Oriental pashas, expect to be waited upon hand and foot. The Greek male considers it 'unmanly' even to lift a little finger.

Fortunately in recent years, the best appliance ever invented hit the Greek home front: the Filipino girl. No-one seems to know how it started, but it caught on like wildfire and now there are some 500,000 Filipino (and other assorted nationalities) maids in Greece – half of them working illegally. Add to these the Greek women from North Epirus and those from Albania who work as charladies, and the future of the Greek housewife looks much brighter than it used to.

The care the Greeks lavish on their homes does not often extend to their surroundings. They may be seen regularly washing the pavement in front of their houses, or whitewashing neighbouring tree-trunks, but they are notorious litterbugs and every summer mass-media campaigns admonish them to keep the countryside and the beaches clean – for shame.

Personal Hygiene

From a statistical point of view the average rate of showers per person is quite impressive. At least 50% of the Greeks shower and change clothes three times a day. The other half, however, does not deem it necessary to have even one shower a day. Hence it's best to avoid taking a bus during rush hours in summertime.

About 99% of women use one or another depilation method for legs and armpits and the market in deodorants is booming. The majority of men use only aftershave lotion, regarding the use of deodorants as rather effeminate.

Very dirty people in Greece tend to be one of three kinds:

a) old peasants, who believe that bathing more than twice a year is injurious to one's health;

b) Albanian illegal immigrants, who have walked all the way from their country and may not have washed since the fall of the communist regime;

c) Gypsy women and children who work hard at persuading passers-by they are so destitute that only a 100-drachma coin stands between them and extinction. The women usually carry an equally bedraggled and filthy squalling baby in their arms (which they rent from

its mother for a cut of the take).

Despite the garlic-flavoured dishes of Greek cuisine, garlic breath is rare. There is instead a lot of gum chewing, usually with the mouth wide open, in the best American tradition. Gum is also used as a substitute for cigarettes by those who wish to quit smoking .

The Greeks not only produce a lot of tobacco, they also smoke it – a staggering 28 billion cigarettes a year. Smoking is regarded as a proof of 'modernity' by teenagers, and given the proverbial Greek self-indulgence, it is difficult for adults to kick the habit.

Their favourite riposte to non-smokers is that of a Greek playwright at the death of a friend: "Poor man. The doctors told him to quit smoking, drinking, women and late nights. And what happened? He died, miserable, but in the best of health – run over by a car."

Systems

Greek systems are a far cry from, say, the clockwork regularity of the German ones. Some work (after a fashion), some do not (usually for no apparent reason), so one should be prepared for anything. The trouble is that even the concept of 'system' is incomprehensible to most Greeks, although they constantly grumble at the legendary malfunction of theirs.

Athens is perpetually short of water and its supply network terribly antiquated, with the result that in periods of drought the Athenians have to cut down their water consumption or pay exorbitant fines. Drought can also cause problems to the power lines, threatening the whole country with a blackout. Too much rain and bad weather

conditions pose the same threat and usually put the country in a state of emergency.

Telephones are not much better: accidental eavesdropping on other people's conversations is common, and so is getting the wrong number – and paying for it.

Public transport seems innocent of any schedule and rush hour provides proof of the old maxim: 'There is no tin in which you cannot fit an extra sardine.' Domestic flights are not famed for their punctuality and though the international flights run on time, the joke about Greece's national airline is irresistible.

An airplane is about to land in New York, and the pilot asks the control tower for the time. "If you are Pan Am," answers the operator, "the time is fourteen hundred. If you are Air France, it's two o'clock. If you are Olympic Airways, it's Tuesday."

Taxis are never available when one most needs them, despite the fact that Athens has more taxis than any other European capital. A taxi can be hailed in the street even if occupied. As it slows down, you shout the general area of your destination to the driver. If it matches that of the other passengers, you are taken aboard, but expected to pay the full fare (from the point you got in) as if you were riding alone.

'In Greece,' so the saying goes, 'nothing is more permanent than the temporary.' However, with the intended privatisation of most public services, and the necessity to catch up with fellow members of the European Union, things are gradually improving and their function may no longer depend on temporary measures.

On the other hand, it is equally probable that in a United Europe the Greeks may be a bad influence on the other Europeans, subverting them into enjoying life more, working less, and letting tomorrow take care of itself.

One thing is certain: wherever you have an appreciable

body of Greeks, very soon the particular system they are involved with will start functioning their way.

Education

There is no system the Greeks denounce more vehemently than their educational one. As usual, no-one does anything about it – least of all the teachers.

For example: formal education in the classics has more or less been abandoned as too onerous for the children (only a smattering is given); spelling errors are not corrected in class lest it cause childhood 'traumas'; and most schools have a shortage of classrooms, so children are taught in shifts. (Private schools are much better, but very dear.)

Entry to universities (all state-owned) is subject to nationwide exams, so – since the dream of every Greek parent is to see his children graduate in no matter which field – whole fortunes are spent providing them with supplementary private tutoring. Usually the same teacher who in the morning is unable to hammer the curriculum into his students' heads, is doing it successfully in the afternoon for a whacking fee.

Those who fail in the exams, and whose parents can afford it, go abroad for their studies: entry is much easier and a foreign degree carries much-coveted cachet back home.

Higher education also helps the boys postpone having to face the hardships of army life (there is a 17-month conscription term for men, while the women's corps is made up of volunteers), but serve they will – even at the age of 35. The other soldiers call them 'grandfathers' and tease them mercilessly, but there is no way out, unless they want to plead insanity or turn up at the recruiting office in drag.

Beware of Greeks Behind a Wheel

Nerves of steel, a trapeze artist's reflexes and an exceptionally vigilant guardian angel are the qualities required of a good driver in Greece, if he wants to survive intact.

The Greeks have a love/hate relationship with their dashboard, so the unsuspecting motorist has to figure out for himself whether the car in front of him is going to change lane, turn, slow down or even stop dead in its tracks without warning.

Jumping a stop sign, overtaking, and a million and one other infringements of the highway code are the rule rather than the exception, as is the use of the horn at the slightest provocation. What is the smallest fraction of time the human mind can register? The time that elapses between the moment the light turns green and the moment the Greek behind you leans on his horn.

A driver in Greece needs excellent peripheral vision and has to look both right and left when abreast of an intersection, no matter what the roadsigns say. The rule that vehicles coming from the right take precedence over the others is invoked only after the crash, in order to establish at whose door the blame should be laid.

Motorcyclists, usually unhelmeted, slalom among the cars with blood-curdling insouciance and deliberate disregard for the fact that pavements and pedestrian precincts are only intended for pedestrians.

Crime and Punishment

Greek law is mainly based on the German Penal Code, (since Otto, the first king of modern Greece, came from

the royal family of Bavaria), which means that one has to prove one's innocence to the court. Happily there are no strange or antiquated laws that could possibly be infringed unwittingly.

Yet, if you want a Greek to do something, you label it 'forbidden'. When the first load of potatoes was brought to Greece in the 1830s, the authorities wanted to distribute it to the famished population of Nafplion (then the seat of the government). For days there were no takers, the people being suspicious of the unfamiliar tuber. With a stroke of genius, the Chief of Police ordered an armed guard around the mountain of sacks filled with potatoes. Next morning there wasn't a single one left.

Greek policemen are usually very polite and helpful – unless given substantial reason not to be. Apart from chasing after ordinary criminals, their efforts are mainly directed towards:

a) Catching the local Left-wing terrorist group, '17 November'. The political assassinations it commits leave Greeks aghast, but its members – though they operate in broad daylight – have proved extraordinarily elusive.

b) Apprehending the drug smugglers who see Greece as a convenient stopover between the poppy fields of the East and the markets of the West.

c) Preventing Greek antiquities from leaving the country in the luggage of innocent-looking tourists who claim they picked up a few valueless pieces of marble as souvenirs. (This is an argument that cuts no ice with the police since Lord Elgin, when he carted away half the Parthenon in 1802, described his loot as 'some stones of no value of themselves'.)

d) Rounding up by the hundred the Albanian riff-raff (who descended like locusts upon Greece after Albania

opened its borders) and returning them to their country.

This is a Sisyphean* labour since they come back again and again – the border area being too mountainous to be effectively patrolled. Destitute Albanians see Greece as a heaven where they can work (illegally) and send money home. The majority though, join the ranks of the 'Albanian Mafia' and practise their age-old profession: brigandage. They roam the countryside and the more run-down quarters of the cities, stealing anything that is not nailed down. Shoot-outs among rival gangs, or even with the police, are not uncommon, neither are murders nor the occasional rape.

Greek prisons are not recommended either for their accommodation and facilities, or for their cooking, although foreigners residing in them are better treated than the locals. Bribes can provide comforts, but the best course is to avoid being a guest at such an establishment.

Government and Bureaucracy

It is a well-known fact that most people get the government they deserve. Nothing could be more applicable to the Greeks. Their successive governments – regardless of their political colour – usually display the same faults as an average Greek (only more pronounced). Since nothing and no-one can make the Greeks register the fact that for the past 150 years their governments are flesh of their flesh, they complain incessantly because those they have elected to govern them fall short of their expectations.

*Poor Sisyphus, who was condemned for eternity to roll a boulder up a hill but which always rolled down again.

But when it comes to action – that is, to pressure groups or banding together in any form in order to right wrongs – they shrug their shoulders and exclaim: 'This is not our job', fully expecting the government to be Merlin, Mary Poppins and Croesus rolled into one. The statement 'Don't ask what your country can do for you, ask what you can do for your country' has not yet penetrated Greek consciousness to any appreciable depth.

Yet the phrase 'If I were Prime Minister...' is the favourite conclusion of a political discussion for most Greeks; and they proceed to enumerate, with great conviction, how they would solve, single-handed, all the problems that have pestered Greece for ages.

The Greeks, despite their undoubted intelligence, are a gullible people when a charismatic politician tells them what they want to hear. They follow him to bitter disenchantment, and then turn to the new charmer who steps into the limelight. They invariably expect each new leader to conjure out of thin air everything the country lacks and to offer them a new Golden Age. When he doesn't deliver they turn nasty and vote him out of office.

In general the Greeks regard their politicians with contempt – even those they vote for. They consider them corrupt and prone to feathering their own nest. 'Who wouldn't lick his fingers if they were smeared with honey?' is the popular Greek saying, and if a politician does just this very discreetly, he incurs no blame. Dipping his whole hand in the honey pot, though, gets talked about, and provides the satirists with plenty of material for their revues, but the culprit more often than not gets away with it.

The Greeks easily catch the bug of fanaticism, which is fanned by the press to a degree unheard of in other countries. Civil strife has been the bane of Greek society

since time immemorial. Ideals usually play a very small part in choosing sides, although one will rarely hear a Greek admit it. Adherence to a particular party depends more on whether its leader catches the public's fancy, on his powers of persuasion and on the effectiveness of his propaganda network, than on his programme or his performance. The decisive factor is always the personal benefit one may expect once the party of one's choice comes to power.

Whether that party will also benefit the country is a matter over which very few Greeks lose any sleep.

Bureaucracy

Other people have bureaucracies, the Greeks have 'connections' – usually a cousin-in-law thrice removed, a *coumpáros*, or a friend of a friend – in any given ministry or public service. (Small wonder in a country where more than one tenth of the population is some kind of civil servant.) These friends can speed things along, sometimes as a favour, other times for a kick-back commensurate with the importance of the service requested. (There is even a boisterous pop song that claims 'They all take bribes – and fat ones at that'.)

However, those who do not hold a key to the bureaucratic maze find things very different. This is because bureaucracy in Greece has been elevated to a form of art: the art of making enemies of the citizens. The Greek who has managed by hook or by crook to become a civil servant is – nine times out of ten – neither civil nor a servant of the public he is supposed to serve.

Barricaded behind his desk, he becomes a 'chair-centaur' – that is, a petty dictator who is afraid of taking any decision and who delights in torturing the unfortu-

nate citizen whom evil fate has thrown at his mercy. Even obtaining a simple certificate is a major operation, involving several hours (or even days), dealing with at least six people – who treat the applicant with varying degrees of indifference, rudeness and pure malice – and miles of corridors and badly-lit stairs in order to get a signature from the one, a rubber stamp from another, an initial from a third, etc. Getting entangled in Greek red tape makes Kafka's *Trial* look like a pleasant walk in the park.

There may be civil servants who are far from slothful, who go to their office in order to work – not just to loll about reading newspapers and gossip with friends – who do their best to serve the public efficiently and courteously, but they are an endangered species. They are calculated at being some 10-20% of the public sector's workforce and it is only thanks to them that the country has not yet fallen apart.

Business

The Greeks were the first people to have a god of trade. Hermes (i.e. Mercury), the messenger of the gods, was also patron god of commerce. (He was patron god of thieves as well, but one should not jump to conclusions.)

Having had thousands of years of training, the Greeks are good at business – particularly when they reside abroad: on a list of the 100 richest people in the world, a surprising number are Greeks.

In general, they believe in free trade, fair dealing and keeping one's word. They are quick at grasping (and inventing) complicated business and financial arrange-

ments and they are past masters in acting as middlemen – which means that they are paid by both parties while risking nothing themselves.

When abroad, they conform to the business ethics of their host country. In Greece proper they display all the characteristics that make a Greek admirable or infuriating: they are enterprising, industrious, the epitome of improvisation when anything goes wrong, but they can also be lazy, indecisive, negligent, frustratingly inefficient. There are instances when the barest minimum of personnel can achieve outstanding results in record time, just by sheer willpower and ingenuity, and others which can only be described as *Parkinson's Laws* Greek-style:

Parkinson: *Two persons do in half an hour the work one person does in one hour.*

The Greeks: Two Greeks do in two hours the work one Greek does in one hour.

Parkinson: *A person extends his work to fill the time available.*

The Greeks: A Greek extends his work to fill the time available, plus half as much again as overtime.

The diplomatic manager, who knows how to appeal to a Greek's better self, has a character strong enough to command respect, believes in fair dealing and keeps his word to his employees, will receive in exchange great loyalty and unstinting effort from at least 70% of his staff.

Approximately four fifths of all businesses in Greece are family ones, which ensures the loyalty of employees since most of them are connected to the owners by family ties, friendship or even regional origin. Thus the right recommendation is more important than qualifications,

because the Greeks firmly believe that 'Better the known faults than the unknown merits'.

A distressing fact of Greek economic life is that the rules of the game are constantly changing. Every new government seems to feel honour-bound to change the Inland Revenue System every few years, so that only an accounting wizard can make head or tail of what applies where. Another is that the Greek IRS *a priori* mistrusts the taxpayer and resorts to Shylock-type tactics, endeavouring to collect what it thinks is its due.

Given the loopholes in the system and proverbial Greek ingenuity, the honest taxpayer who finds himself treated as a crook by the IRS, while he sees those less honest than himself getting off scot-free, soon discovers a way to cheat the system.

Moonlighting has become so much a national sport for the Greeks, despite the efforts of every single government to suppress it, that their per capita undeclared income is estimated as equal to the declared one.

Greek society is fundamentally male-dominated, but men in executive positions are less chauvinist than elsewhere, and a less qualified male rarely rises above a better qualified female colleague on the strength of his gender.

There are many women in senior positions and they encounter much less 'static' from their male subordinates and command much more respect from their male peers or superiors than they would, for example, in the United States. They succeed in their careers without having to either trade on, or forego, their femininity.

In fact, in Greece sexual harassment is not very common – even towards the traditional secretary. Since most jobs are obtained through the personal recommendations of friends or relatives, who would risk them hearing about a pass having been made at their protégée? Lures are certainly cast, but if they are not taken up, they

are dropped without repercussions.

A total lack of formality prevails in most Greek businesses. Behavioural codes are minimal – and not only between equals in rank. A publisher taxed by a friend for tolerating the disrespectful behaviour of one of his printers replied disarmingly : "I've hired the man because he is a good printer, not for his good manners." This kind of informality has much deeper democratic roots than, say, the first-name conduct prevailing in most American companies, which a Greek might call mere 'window-dressing'.

Informality in manners is complemented by informality in dress, which in most companies, and even in the public sector, is extremely casual, particularly in summer. Some kinds of dress code are loosely enforced in advertising agencies and multi-national companies, but things like the taboos on bare legs, sandals, jeans, low-cut or over-short dresses, T-shirts, etc., which prevail in other countries concerning office wear, are almost non-existent in Greece and would only make a Greek laugh and comment: "If the company doesn't like the way I dress, it should provide me *gratis* with the outfits of its choice."

On Whom Is the Joke?

A popular funny story, the catch phrase of which has become a sort of signal, meaning 'Time we got back to work!' summarises the character of the Greeks and their ability to make the best of anything:

A man dies and goes to Hell, where he discovers that Hell consists of huge cauldrons full of shit – submerged in which the sinners await Judgement Day.

Every hour they are allowed to come up for a breath of

air – and then, "Heads in!" shouts the gigantic Negro overseer of the particular cauldron, hitting on the head whomever seems reluctant to resume his torment with a preposterous wooden ladle. The cauldrons are allotted more or less by nation or country, but since the new arrival was not that bad when alive, he is given the chance to choose the company he would prefer for the rest of eternity.

He thinks hard and then suggests to the arch-Devil that the Swiss cauldron would probably be the nicest – quiet people, orderly, probably cleaner shit...

"Listen," says the Devil. "I like you, so I'll give you a break. Don't go to the Swiss. Their cauldron works like clockwork. You get one breath per hour, and that's that. Go to the Greeks instead."

"But," says the man, "the Greeks are the most noisome, disorganised, unruly, impossible people."

"Exactly! That's why they are better off than anyone else. Just think: their daily load of shit never arrives on time; most mornings the ladle cannot be found; the overseer either falls asleep or gets drawn into heated arguments with them and forgets to give the 'Heads in!' signal – he even goes on strike every so often, demanding better working conditions! So, one way or another the Greeks get more breaths of fresh air than all the rest of the sinners combined."

The Author

Alexandra Fiada was born and lives (as does 40% of the Greek nation) in Athens. She is unable to explain her unusually disciplined nature, but suggests her inquisitive, optimistic individualism is ample proof, if it was needed, that she is a true Greek.

A passionate lover of Greek history, she became a newspaper addict at the age of five and has read avidly all forms of the printed word ever since. Fortunately this is a great advantage in her professional life – publishing.

As editor of a number of magazines including *International History Magazine* and the Greek *Reader's Digest*, translator, and author of *A Short History of Athens*, assorted articles, scripts and documentaries she finds work her principal pleasure. But she claims she cannot function properly without copious cups of coffee, and far too many cigarettes which she defends on the grounds that if smoking doesn't get her first, the smog of Athens will.

She escapes as often as she can either to London to browse the antique markets or to the Greek countryside. Having acquired a plot of land, she longs for the time when she can build her dream house among the olive trees. Meanwhile she plans a pension large enough to guarantee that her relations humour her every whim well into her dotage.